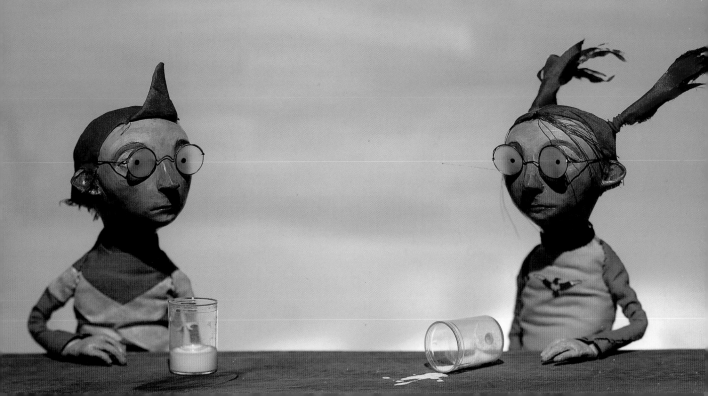

The Look Book

The Look Book

Chris Sickels
AKA
Red Nose Studio

HOW books

Cincinnati, Ohio
www.howdesign.com

11 10 09 08 07 5 4 3 2 1

Distributed in Canada by Fraser Direct, 100 Armstrong Avenue, Georgetown, Ontario, Canada L7G 5S4, Tel: (905) 877-4411.

Distributed in the U.K. and Europe by David & Charles, Brunel House, Newton Abbot, Devon, TQ12 4PU, England, Tel: (+44) 1626-323200, Fax: (+44) 1626-323319, E-mail: postmaster@davidandcharles.co.uk.

Distributed in Australia by Capricorn Link, P.O. Box 704, Windsor, NSW 2756 Australia, Tel: (02) 4577-3555.

Library of Congress Cataloging-in-Publication Data

Sickels, Chris.
 The look book / by Chris Sickels, [dba] Red Nose Studio.
 p. cm.
 ISBN-13: 978-1-58180-940-4 (alk. paper)
 ISBN-10: 1-58180-940-9
 1. English language--Homonyms--Juvenile literature. I. Red Nose Studio.
II. Title.
 PE1595.S53 2007
 428.1--dc22 2007008571

Edited by Amy Schell
Designed by Grace Ring
Production coordinated by Greg Nock

To Jennifer + Owen
for helping me sea differently

· ·

To Mrs. Martin who knew my
drawings could take me places

Only a week into summer vacation, Ian and Ann had played all the games in the game closet, read all the books on the book shelf, and watched all the TV they could stand.

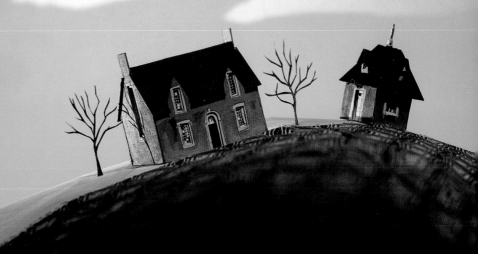

Some morning, Ian looked at Ann and Ann looked at Ian.
They shrugged their shoulders and sighed.

"I'm bored," said Ian.
"I'm bored," said Ann.

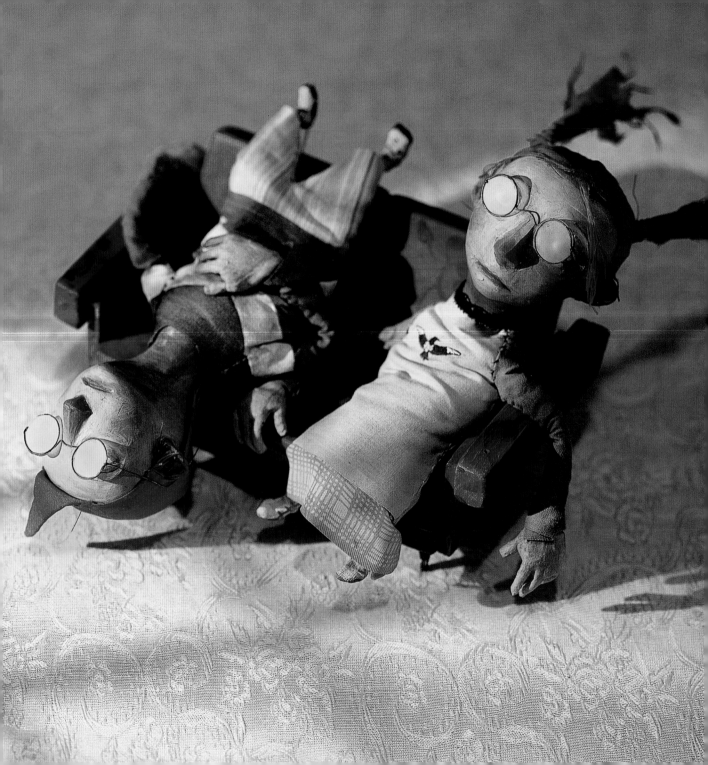

"So We're bored," they complained to their mother.

"Bored?!" she cried.

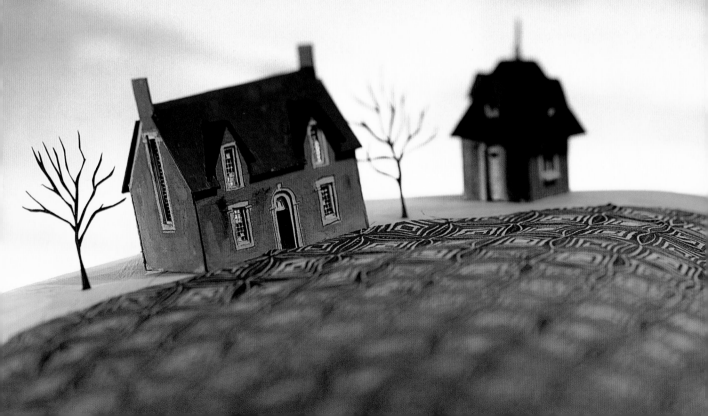

"Why, just go outside and look around. There's plenty to see!"

Ann looked at Ian and Ian looked at Ann. They shrugged their shoulders and headed out the door.

Ann saw a
whole pie

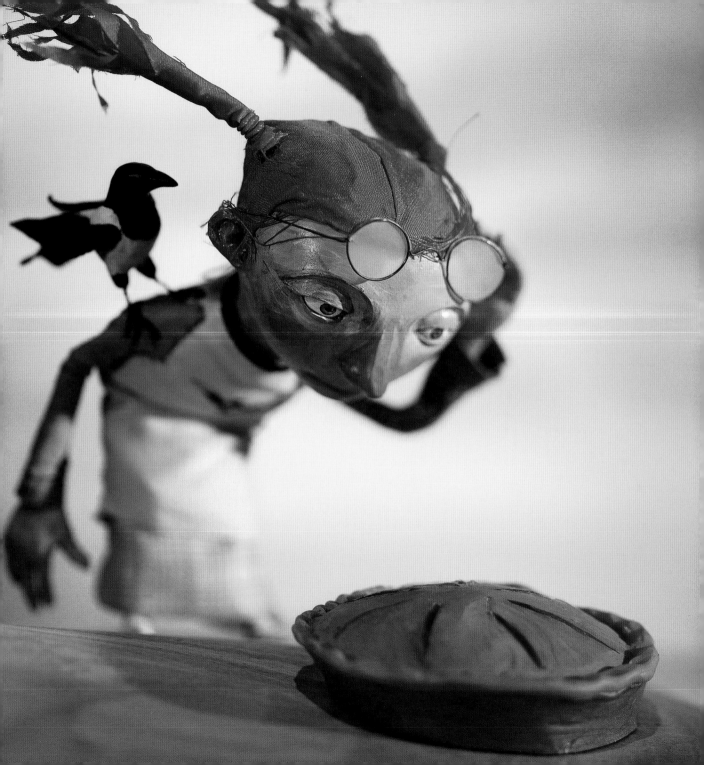

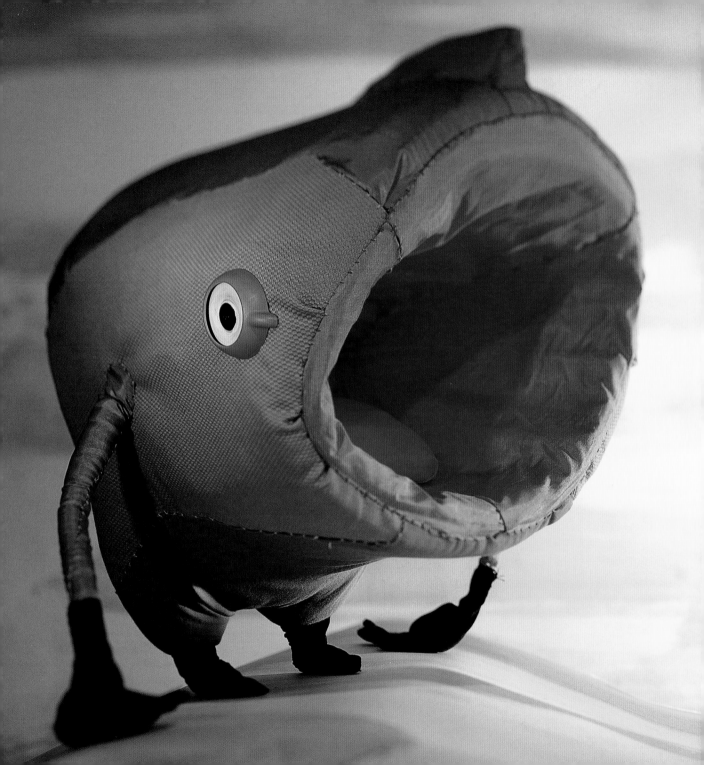

I an saw a
pie hole

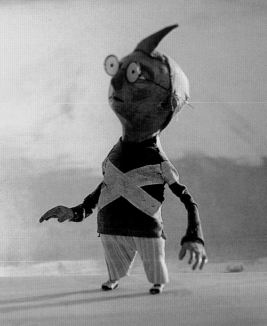

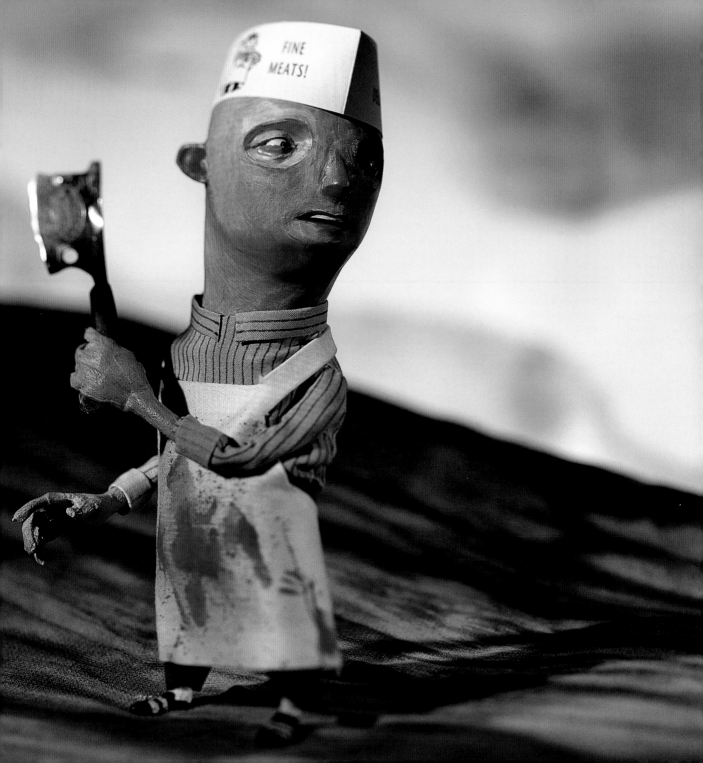

I saw a man that needed to mince something

Ann saw a man
that needed mints
or something

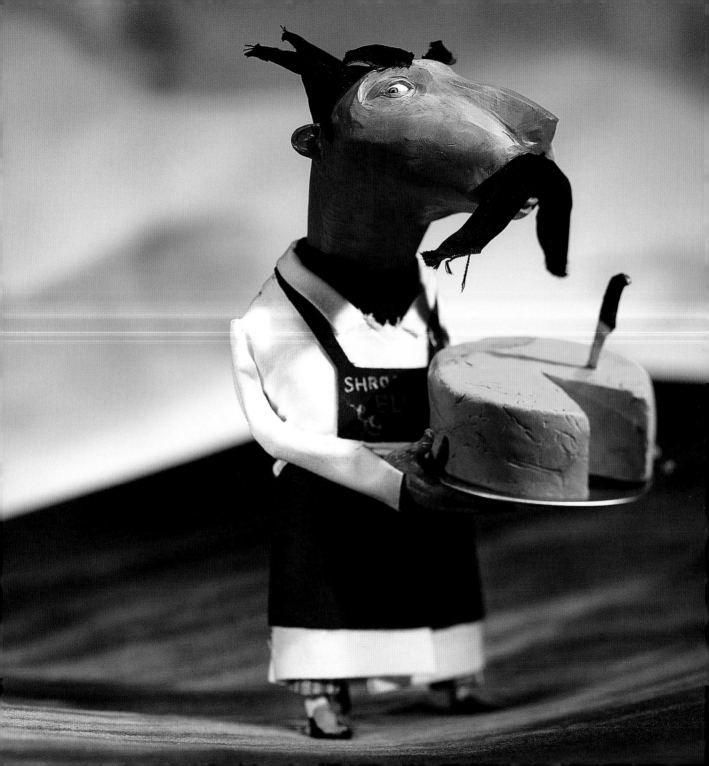

Ian saw a dog
throw up a baseball

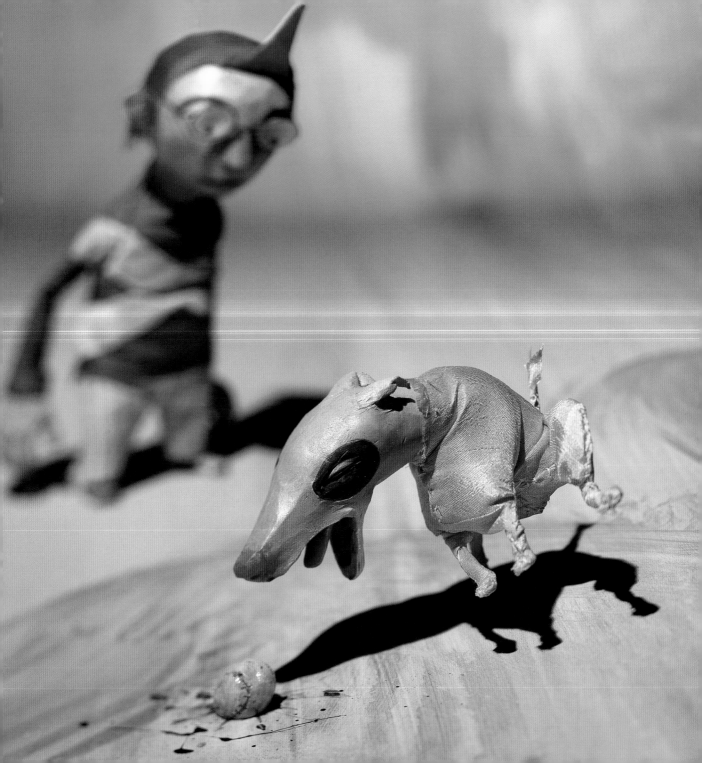

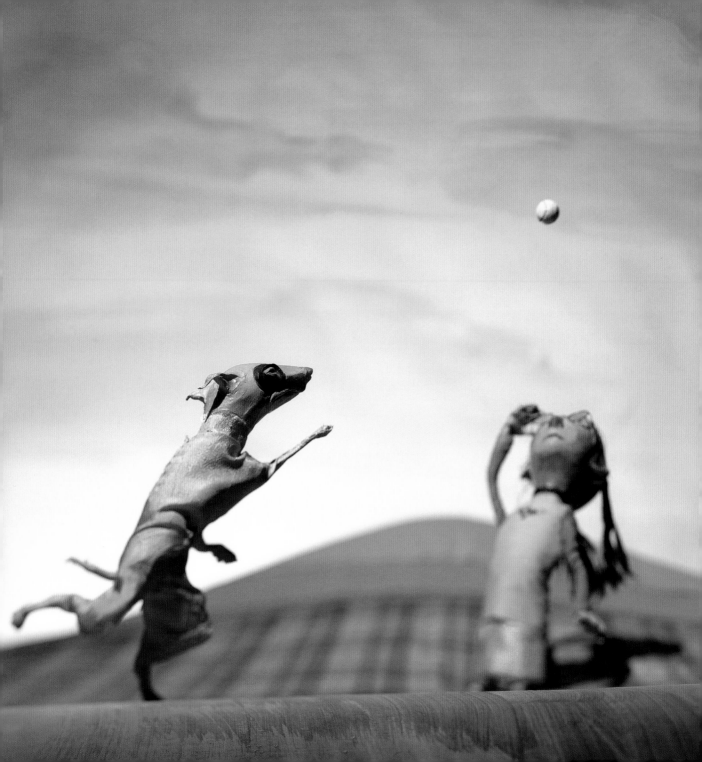

Ann saw a dog

throw a baseball up

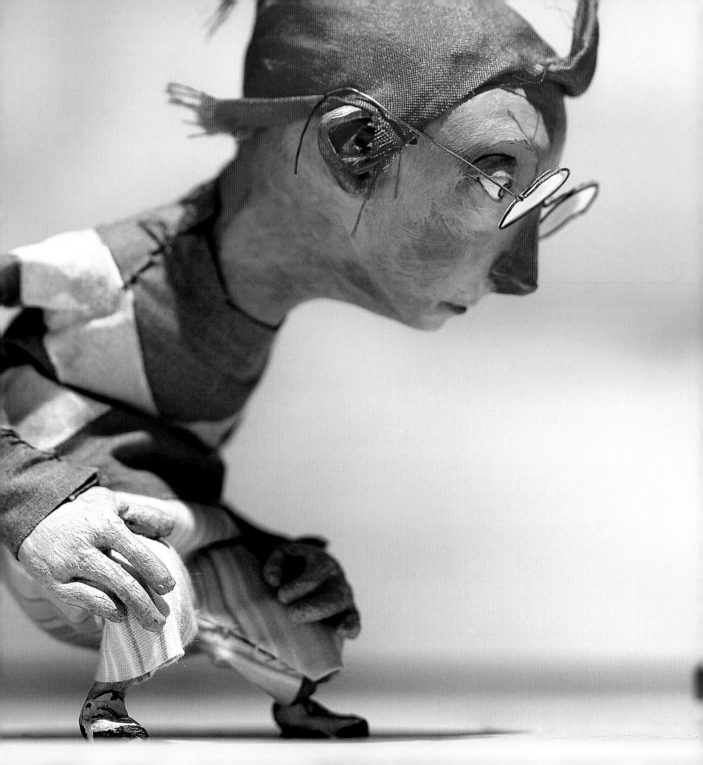

I saw a car

get towed

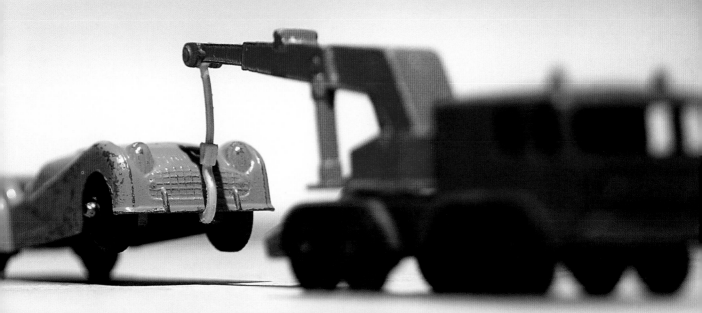

Ann saw a car
get a toad

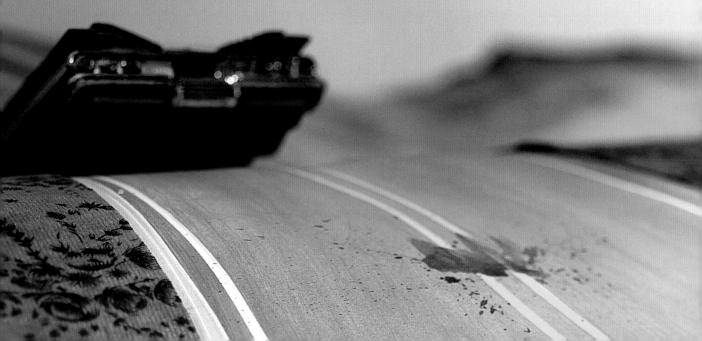

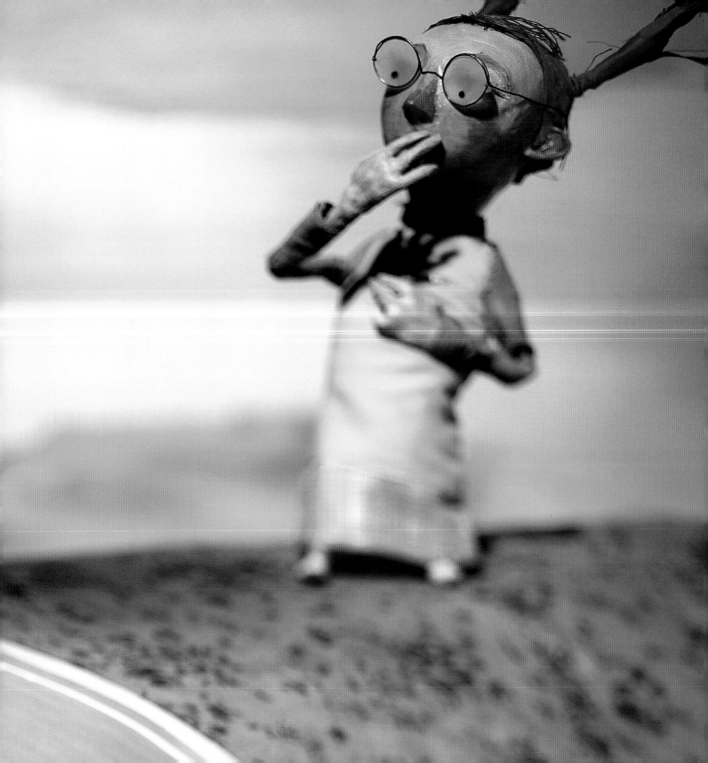

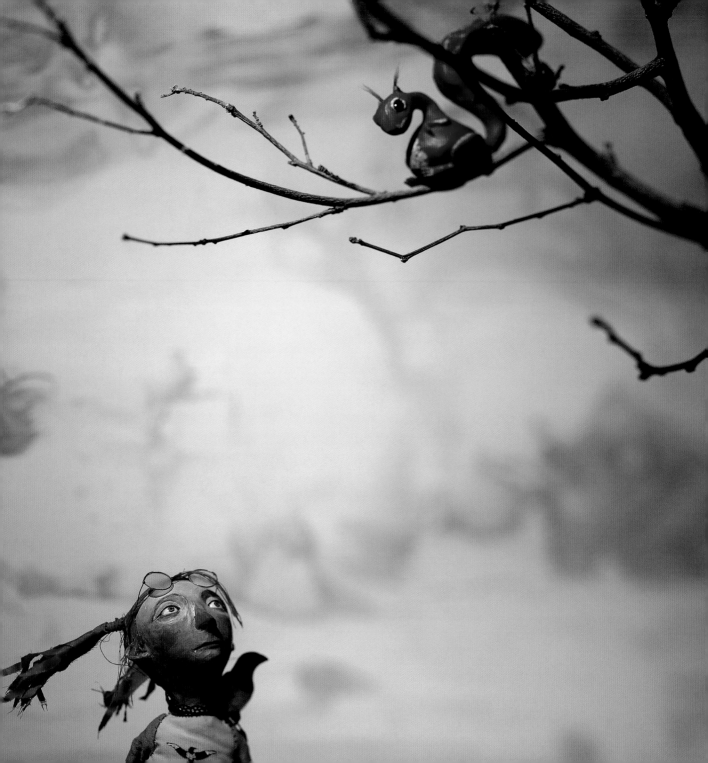

Ann saw a squirrel
shaped like a gourd

Ian saw a squirrel
get gored by a shape

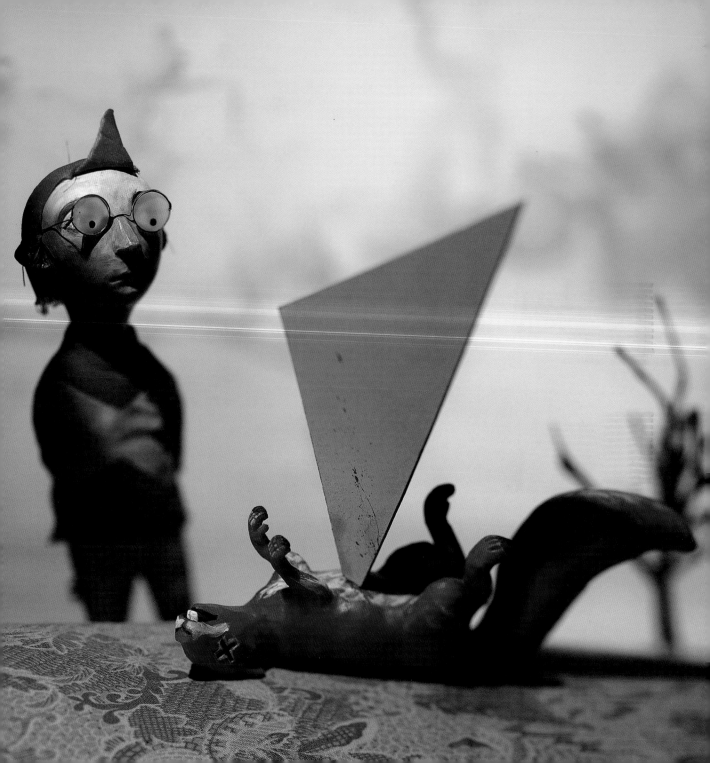

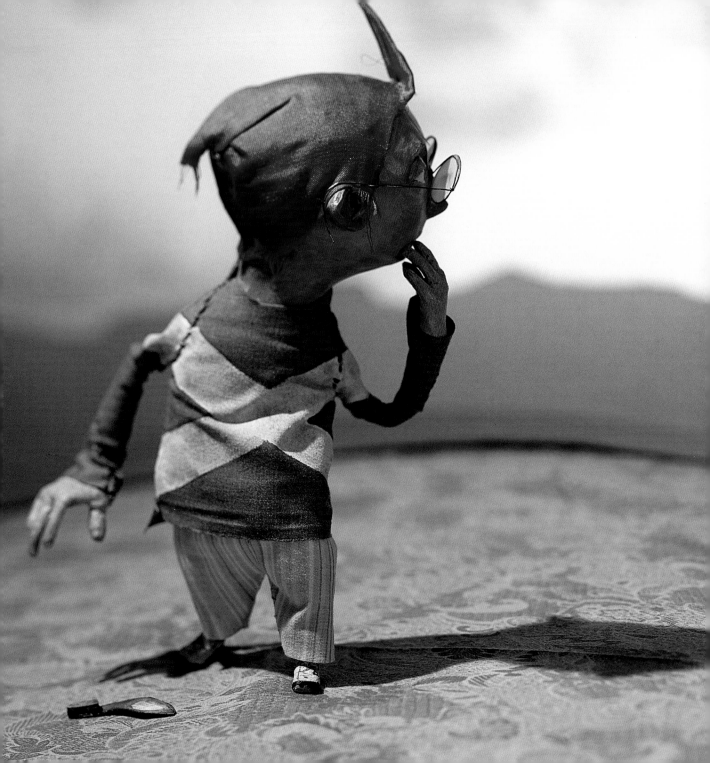

I saw a man
who'd lost his sole

Ann saw a man who'd lost his soul

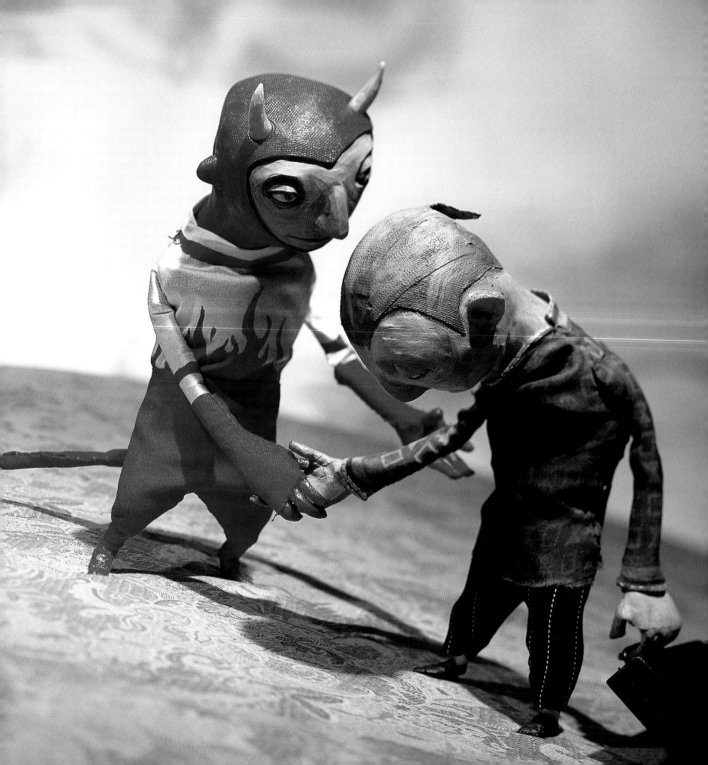

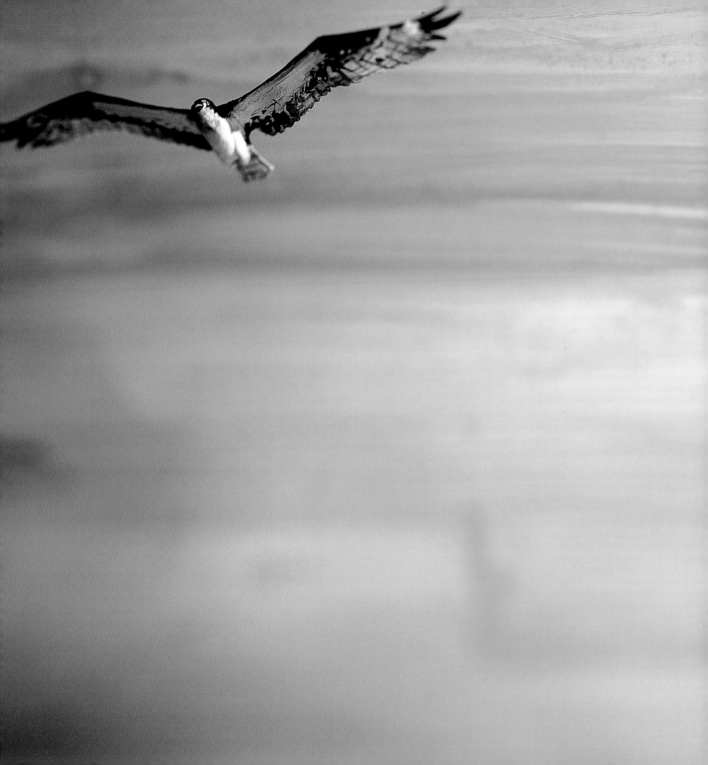

Ian saw a bird soar overhead

Ann saw a bird
with a sore head

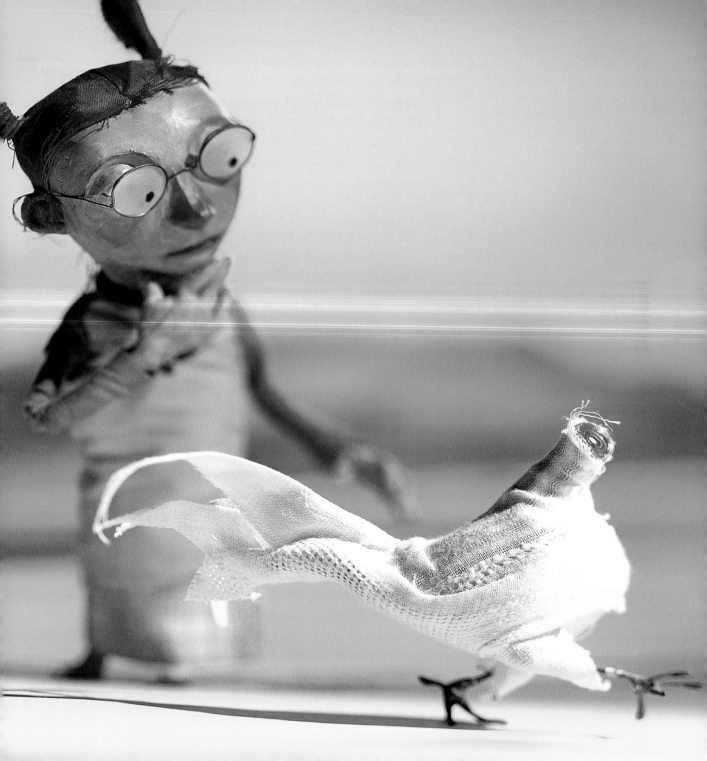

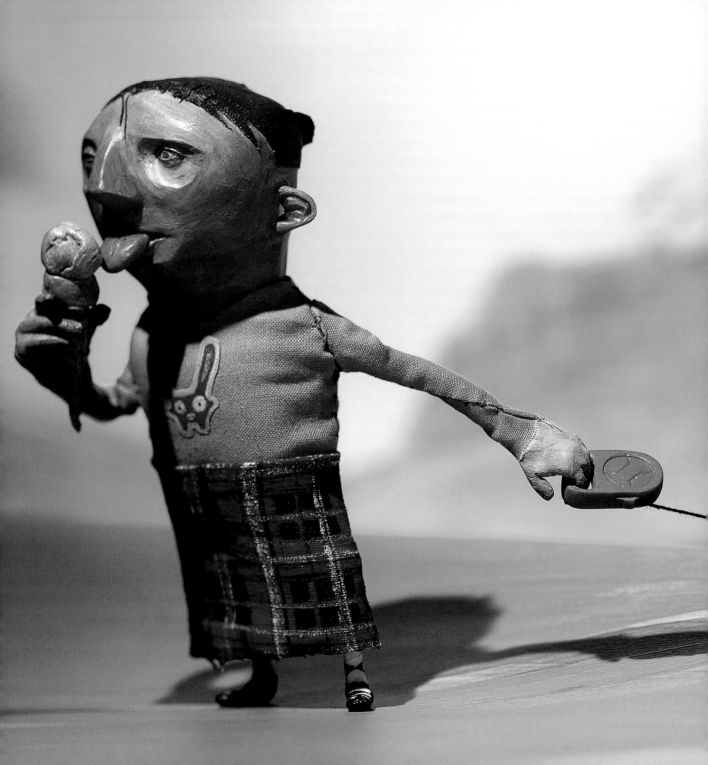

Ann saw a man
with a pet beet

I an saw a man
beat his pet

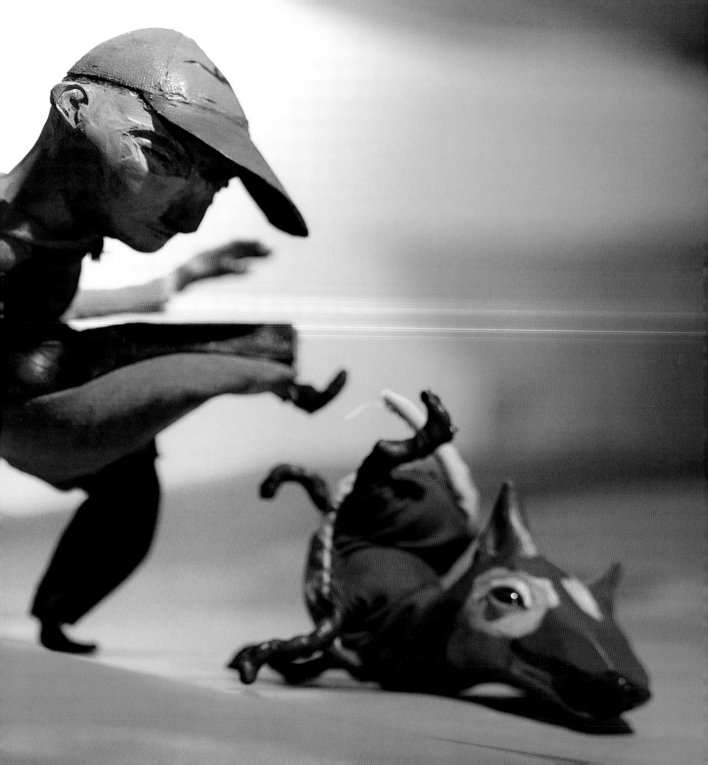

So Ann saw a woman who
had been to the mall

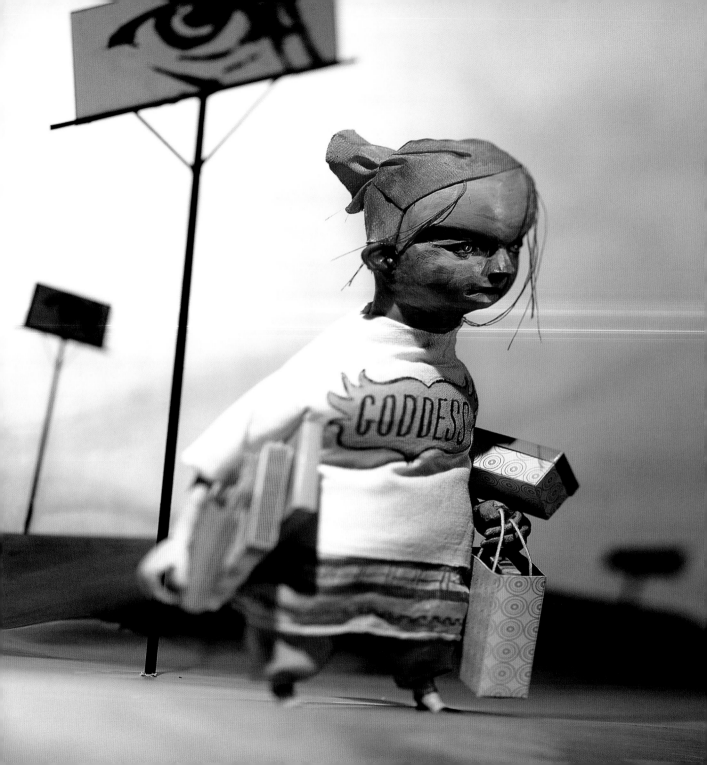

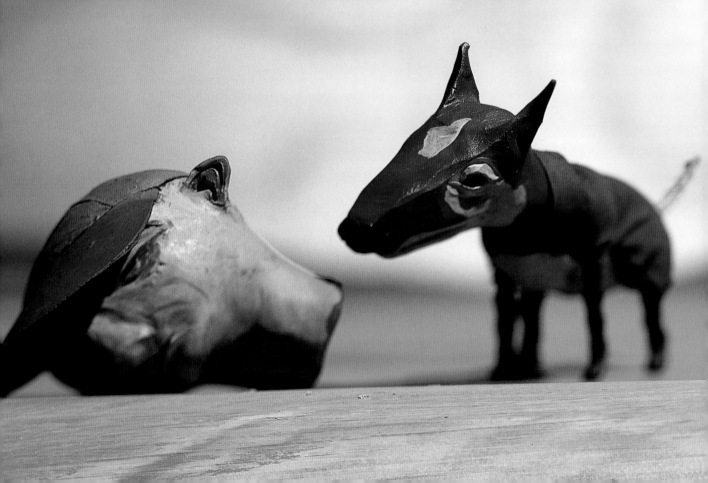

I an saw a man who
had been mauled

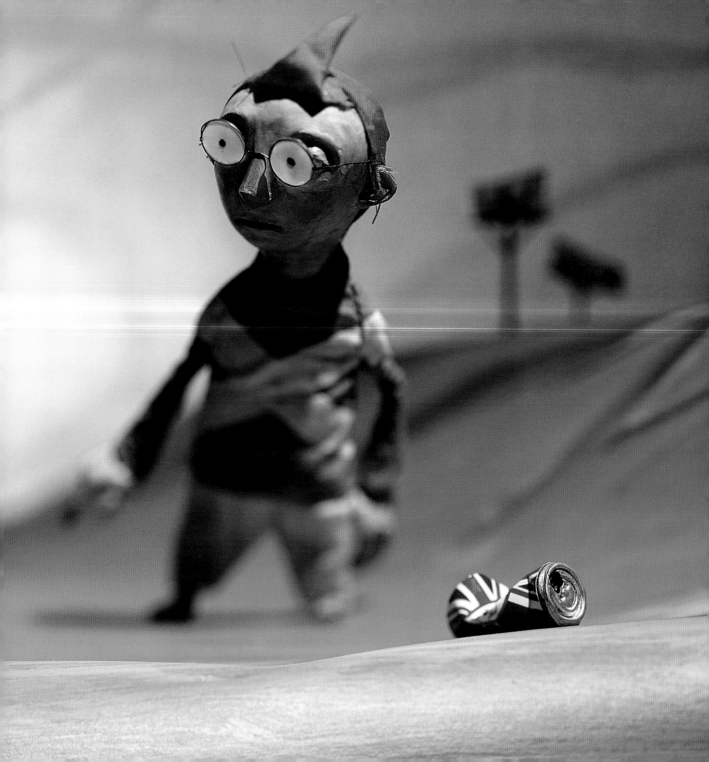

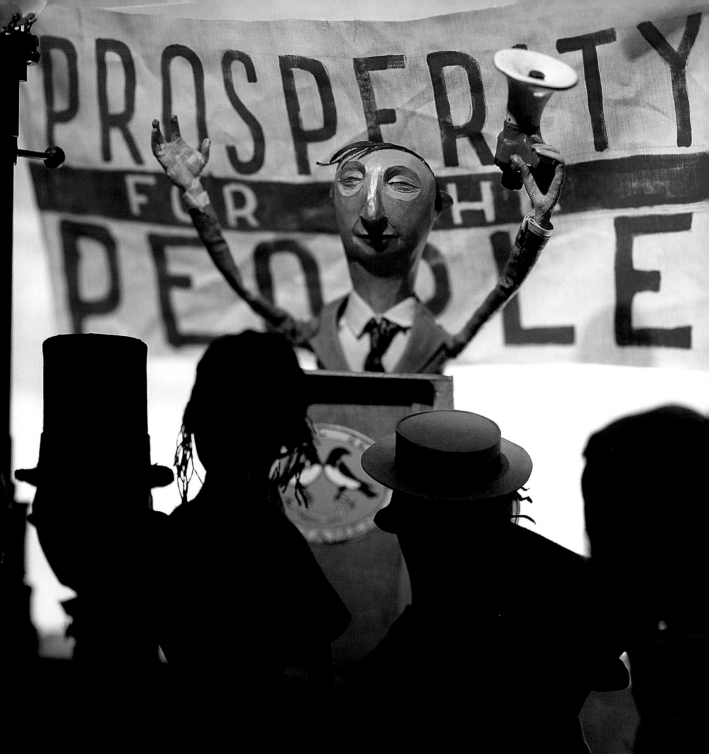

Ann saw a man
allude great things

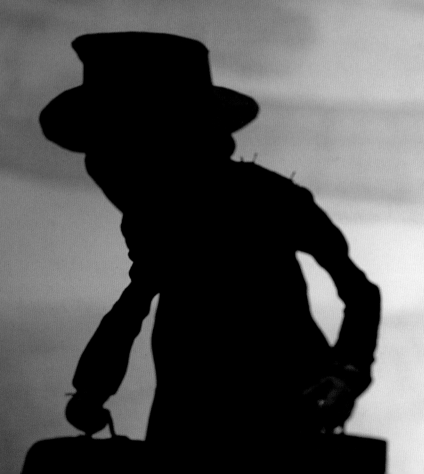

I saw a man
elude great things

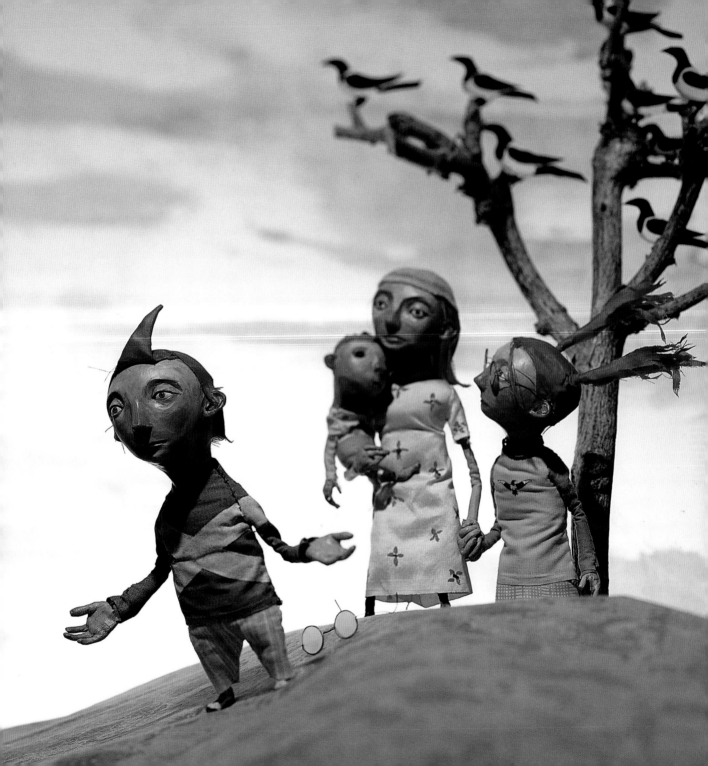

Ian saw a priest exorcising

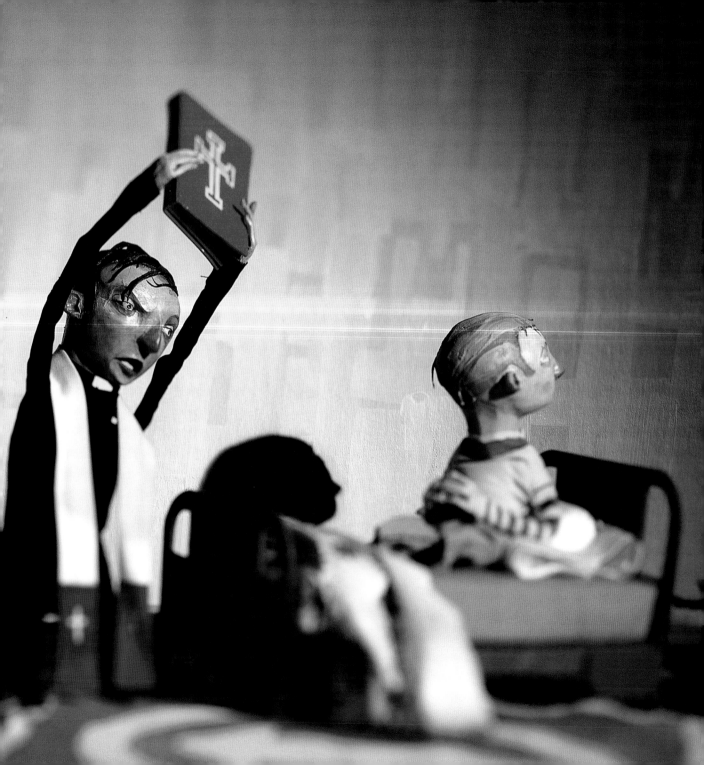

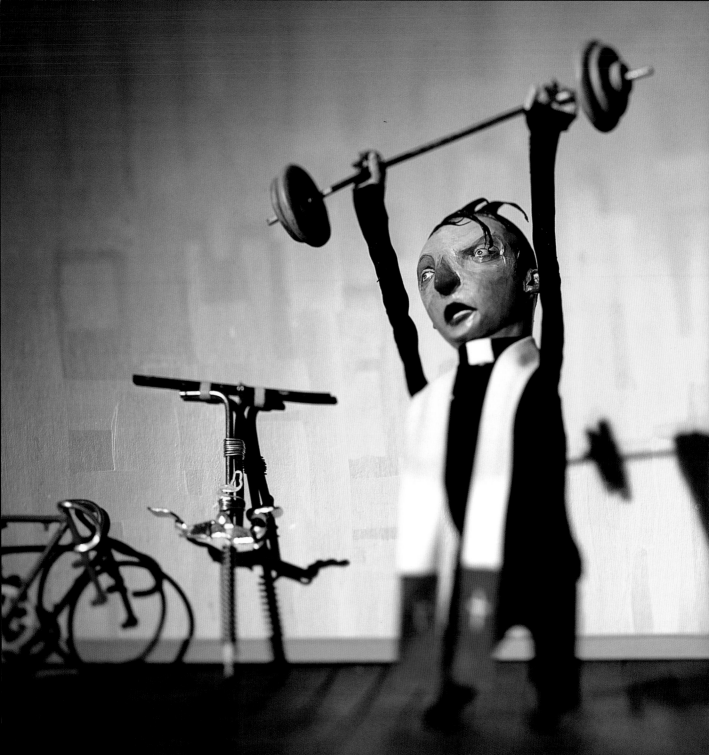

Ana saw a priest
exercising

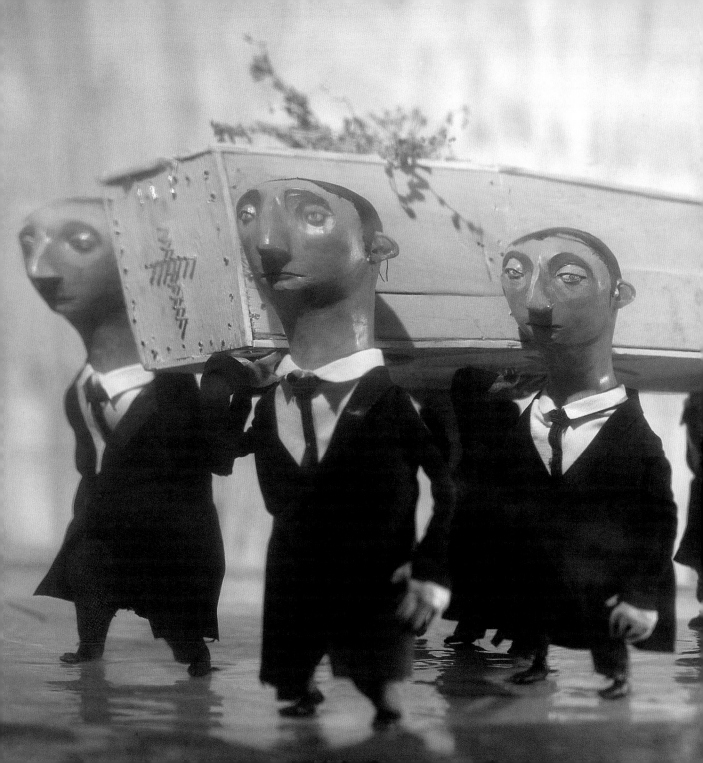

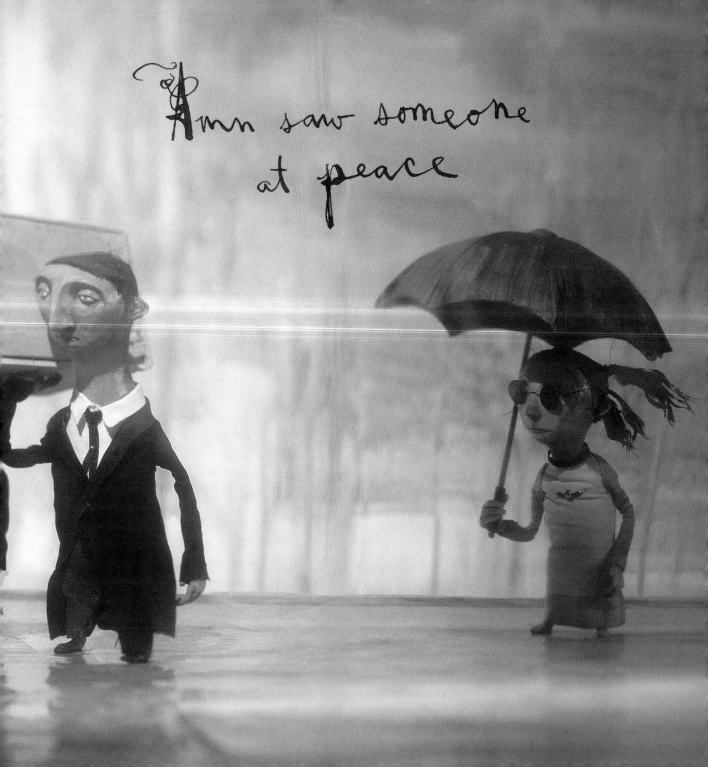

Amn saw someone
at peace

Ian saw a piece
of someone

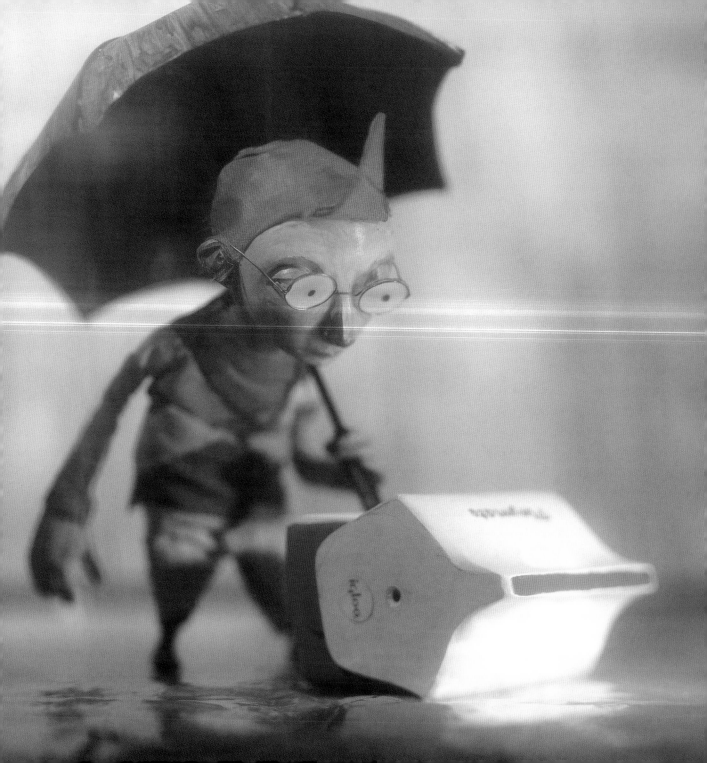

Ann saw a man wail

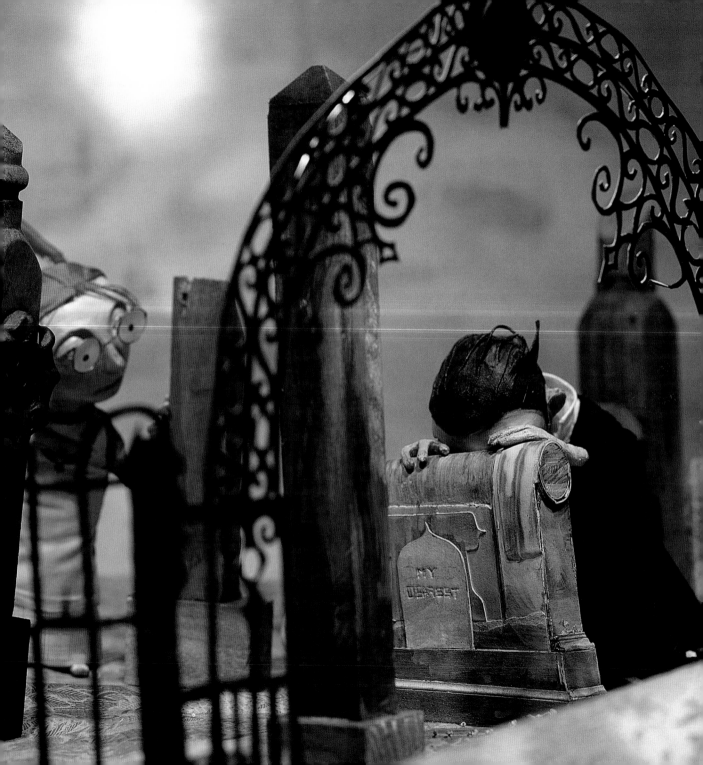

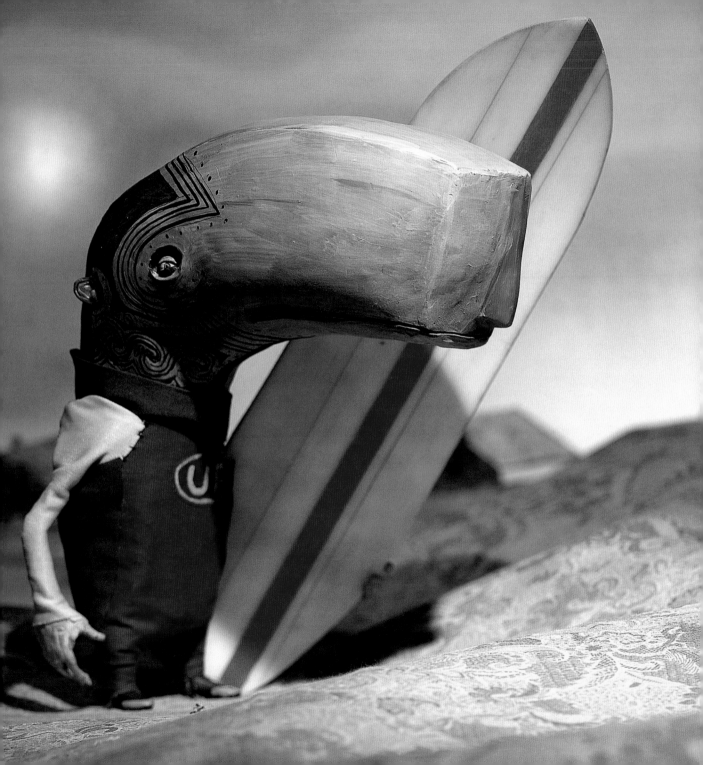

I an saw a whale man

I saw someone
had left his bear behind

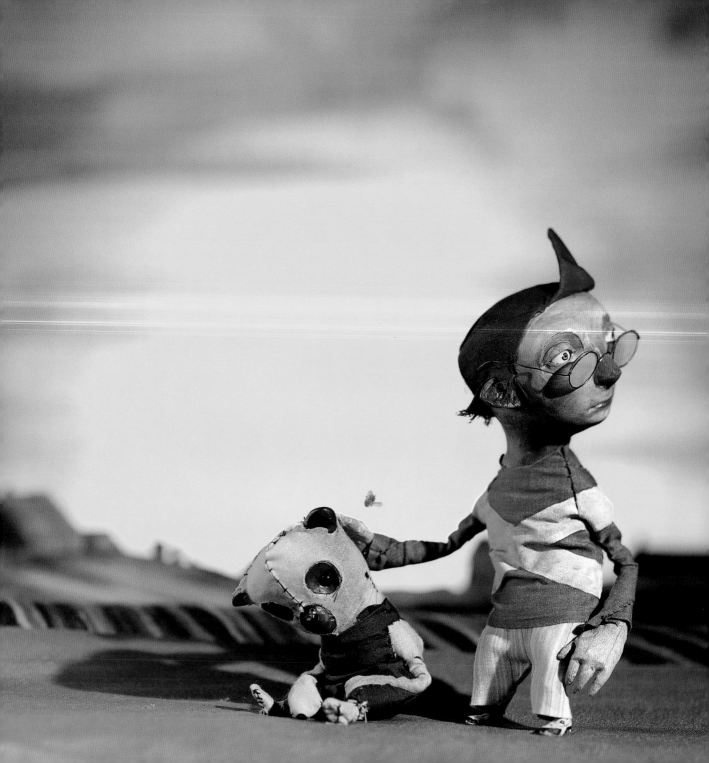

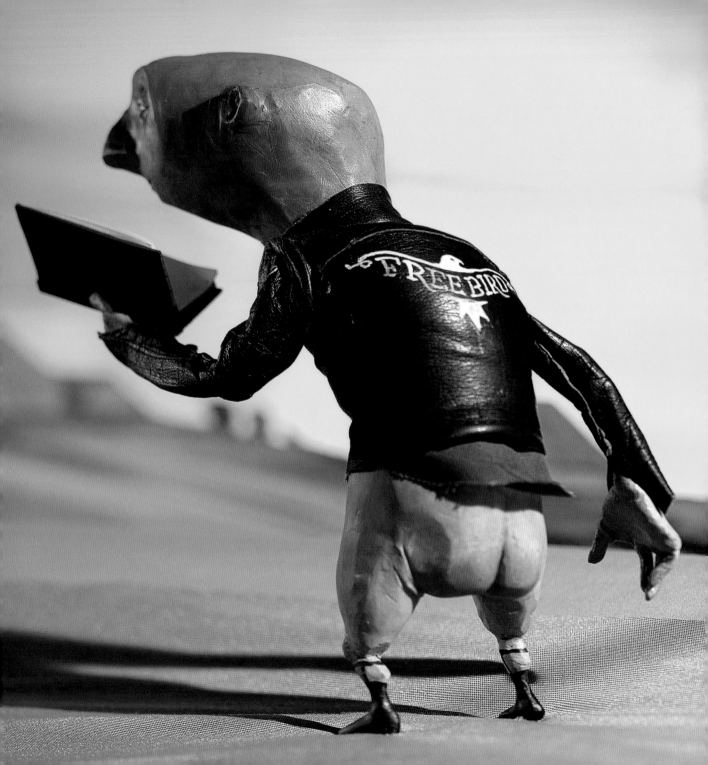

Ann saw someone
had left his behind bare

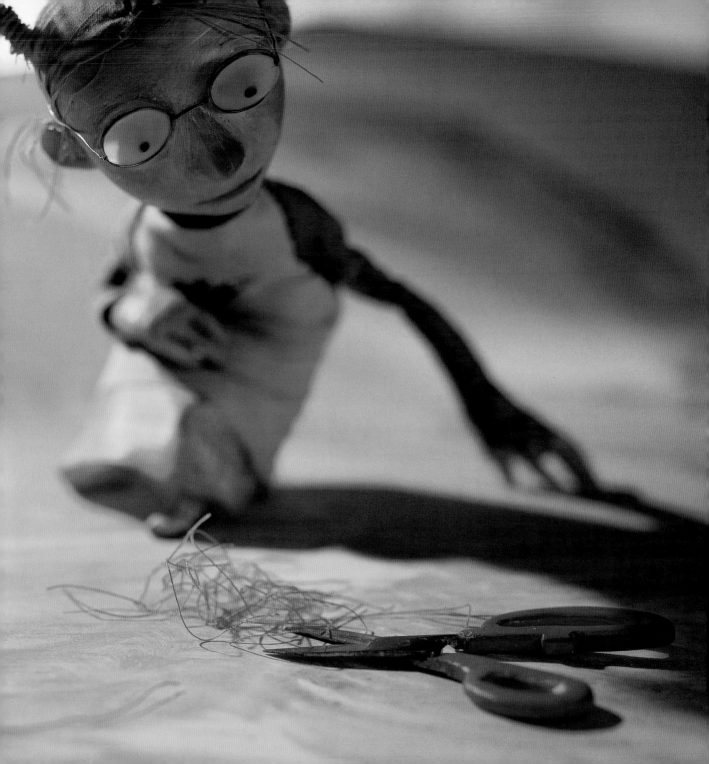

Ann saw someone
had cut her hair

Ian saw someone
had cut her hare

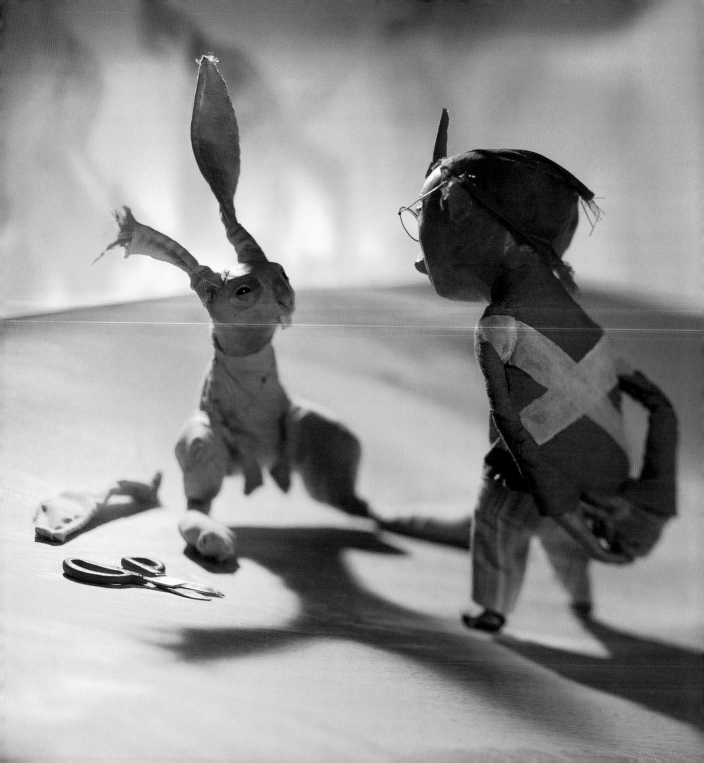

I saw a kitchen sink

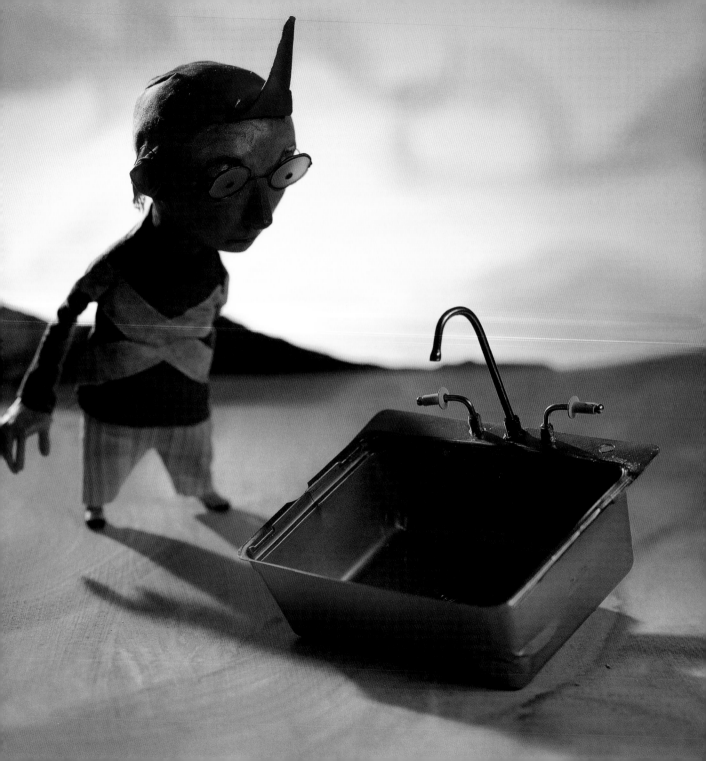

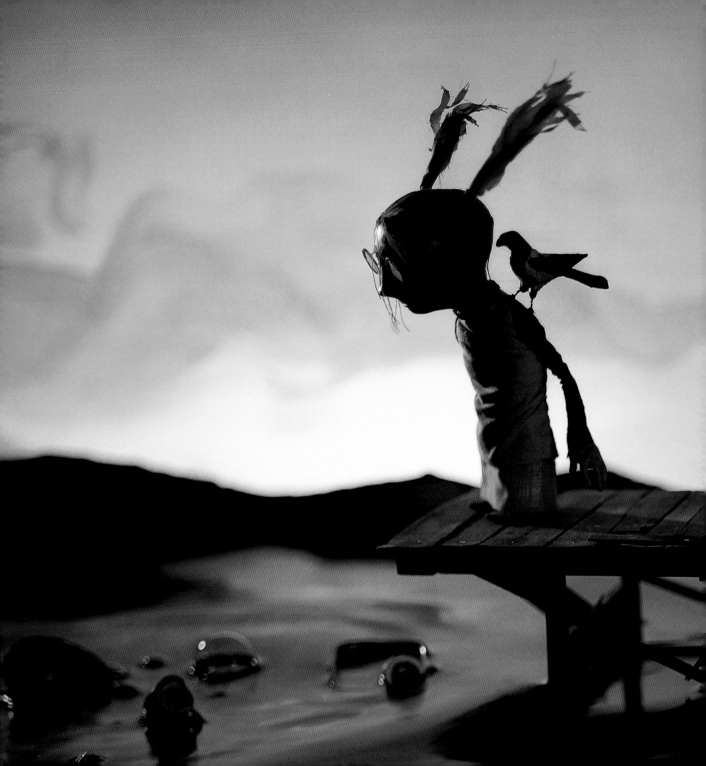

Ann saw a kitchen sink

"When they'd seen all they could see
and the sun was getting low,
Ian and Ann headed for home.

As they walked through the door
their mother smiled
and asked brightly,

"So, what did you see today?""

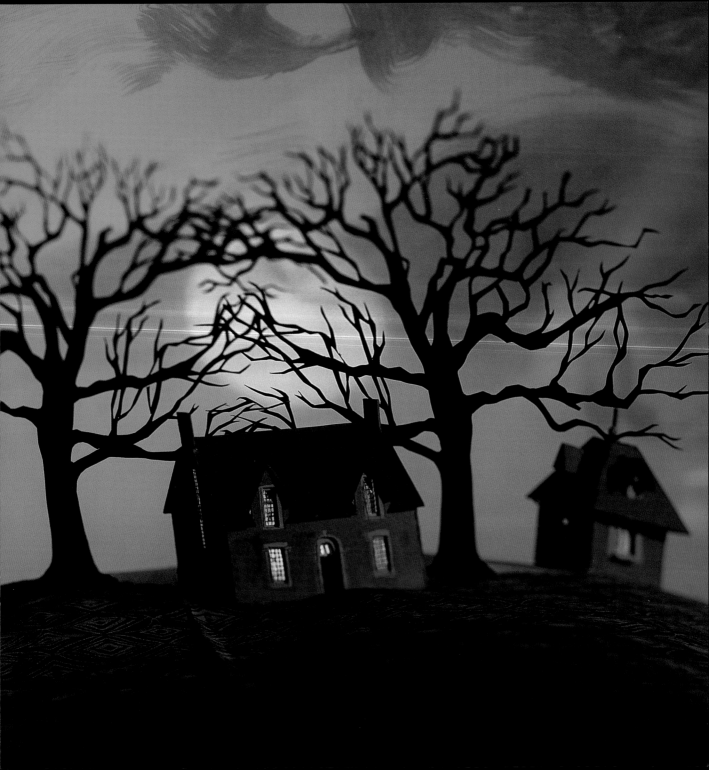

Ian looked at Ann and
Ann looked at Ian.

They shrugged their shoulders
and said,

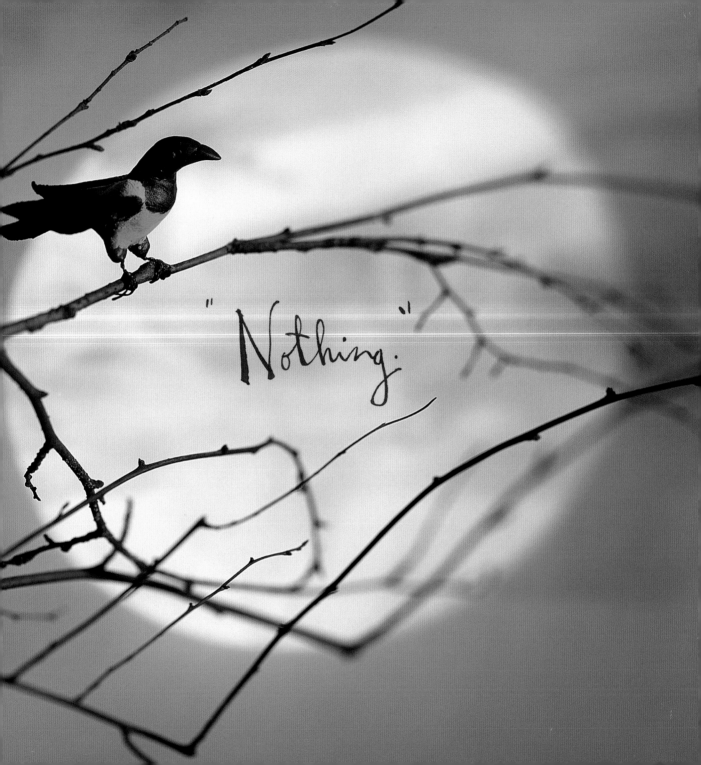

"Nothing."

About the Author

Photo courtesy of Jennifer Sickels.

Chris Sickels, the creative force behind award-winning Red Nose Studio, creates an eccentric world we'd all like to visit. Endearing characters and intricate sets draw you in with wit, intelligence and charm. His three-dimensional illustrations are built from a variety of materials. Sets and puppets are a combination of wire, fabric, cardboard, wood, miniatures, found objects and anything else within arms' reach.

Chris describes his magical work, saying "The sculptures sometimes look pretty crude, or the stitching is really rough, or the buildings are painted really sloppily. They're not poetic, there's no rhythm to them, there's no math to them. But that's how my work is. My work isn't really graceful. It's usually pretty awkward—like if the puppet moved, he'd fall, or he'd trip, or he'd run into a wall. It's a bit of beauty and a bit of awkwardness. And I think that's kind of how I am."

Red Nose Studio's illustrations appear in advertising, magazines, books, newspapers, packaging, character development and animation. His work has been honored by virtually every award institution or annual and has been featured in *HOW, Print, Creativity* and *3x3* Magazine, as well as in a number of art and design books including Taschen's *Illustration Now!* He has twice been honored with the Carol Anthony Grand Prize award from the Society of Illustrators 3-D Salon. Two of his short films, *The Red Thread Project* and *Innards,* were selected to screen at the 2005 and 2006 Los Angeles International Short Film Festival.

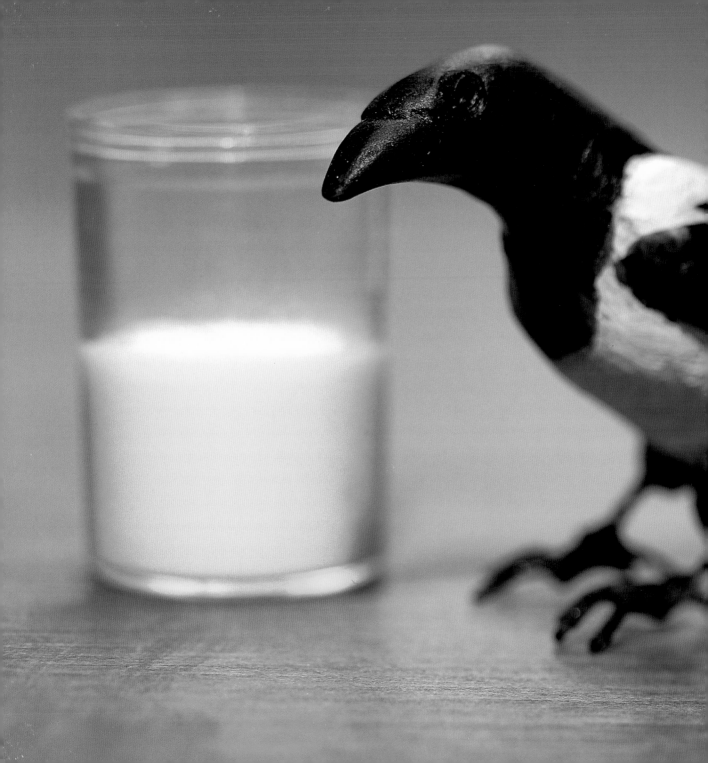